Watercolors

A new way to learn how to paint

BARRON'S

This book is designed to make it easy for readers to learn how to paint with watercolors. The book's pages are read from top to bottom, rather than from left to right, and this means it can be folded in half and turned into an easel.

After a short introduction to the basic techniques of watercolor painting, this book suggests seven exercises to put what we have learned into practice. Each of the exercises is broken down into steps that simply and clearly explain in full detail how to execute each step on the even-numbered pages and show the end result of this step on the odd-numbered pages. In turn, we can use this as a model on our easel.

This novel and practical format makes it easier to see each of the stages of each exercise. At the same time, it leaves readers' hands free to put into practice what they have learned and enjoy painting.

4 WATERCOLOR METHODS

20 WATERCOLOR PROCESSES

Watercolor methods

Water and color

Each color in watercolor painting can give rise to other colors. As we dilute the paint in water, its color becomes increasingly paler. This allows us to obtain successive shades based on a single color, as we can see in the color range illustrated below. Logically, dark colors can give us more shades than light ones. Thanks to this, we can paint a watercolor using just one dark color. This kind of work is called a monochrome wash.

The colors in the top row are diluted in a minimum amount of water. The amount of water increases progressively in the patches toward the bottom.

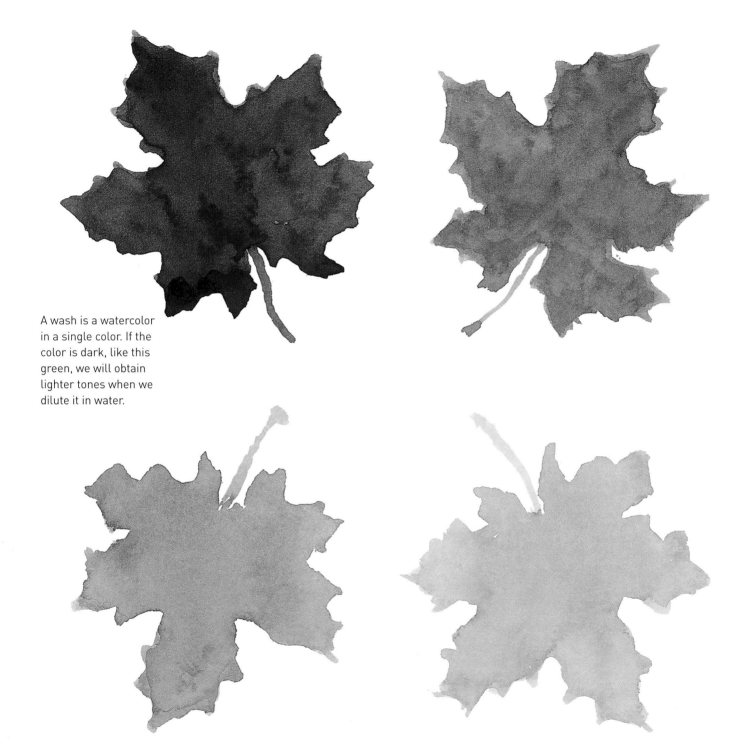

A wash is a watercolor in a single color. If the color is dark, like this green, we will obtain lighter tones when we dilute it in water.

Gradations

A gradation is an application of color that progressively lightens without discontinuities. To create gradations, we start by applying very dark color to the paper; we then load the brush with just water and extend this area of dark paint before it dries. The secret is in controlling the water and the color: the stroke should go from dark to light gradually and uniformly, until it is so light that it can almost be mistaken for the white of the paper.

Each color brings about different gradations, with different effects of volume or luminosity depending on its natural intensity.

This rose contains many gradual shades. We have achieved this by applying a brush loaded with water on the areas of color to lighten them.

The gradation becomes increasingly lighter until it can almost be mistaken for the white of the paper. The color applied was diluted in abundant water.

Here we applied very dark paint; immediately afterward we spread out the color with a clean brush to achieve the gradation.

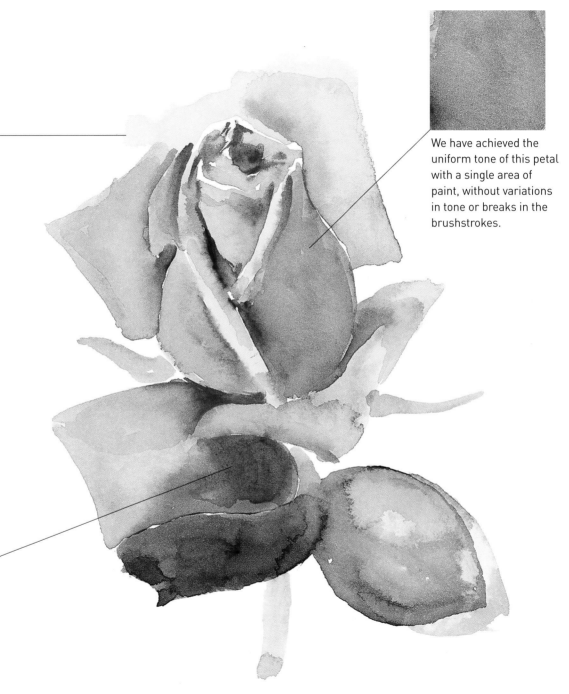

We have achieved the uniform tone of this petal with a single area of paint, without variations in tone or breaks in the brushstrokes.

The transparency of colors

Colors in watercolor painting are transparent, and it is this quality that gives this medium its attractive luminosity: the white of the sheet of paper gives light to the color that covers it. If paint covers another area of color instead of covering the white of the paper, then the effect comes from the combination of the two colors. This effect is similar to that of overlapping tissue paper or gauze fabrics. Transparencies are also called glazes, and the results are much better if we paint on totally dry patches of color.

We obtain transparencies by painting on totally dry patches of color. Some colors are more transparent than others and this overlapping affects them much more.

In watercolor painting, colors are more transparent the more diluted they are. Light colors are usually more transparent than dark colors, although the decisive factor lies in the chemical composition of the pigment of each color.

Watercolors permit very clean transparencies when the colors are very diluted and are painted on totally dry patches of color.

Some mixes are almost totally opaque when they are used in saturated form: this color is a mix of burnt sienna, cadmium yellow, and ultramarine blue.

Dark and cold colors usually dominate in transparencies, prevailing over warm colors.

Reserves

The color white does not exist in watercolor paints: the only possible white is the unpainted sheet of paper. When we have to leave unpainted areas, we talk about reserving the paper and making reserves. This means painting the outside of a shape, respecting the outlines drawn in pencil, so that its white silhouette stands out against a darker background. We later shade the white silhouette that makes up the reserve with shadows or transparencies.

Reserves are silhouettes left in white. We can retouch the inside once the color surrounding them is dry.

The effect of the reserved shapes is great luminosity, particularly if the colors that surround it are dark.

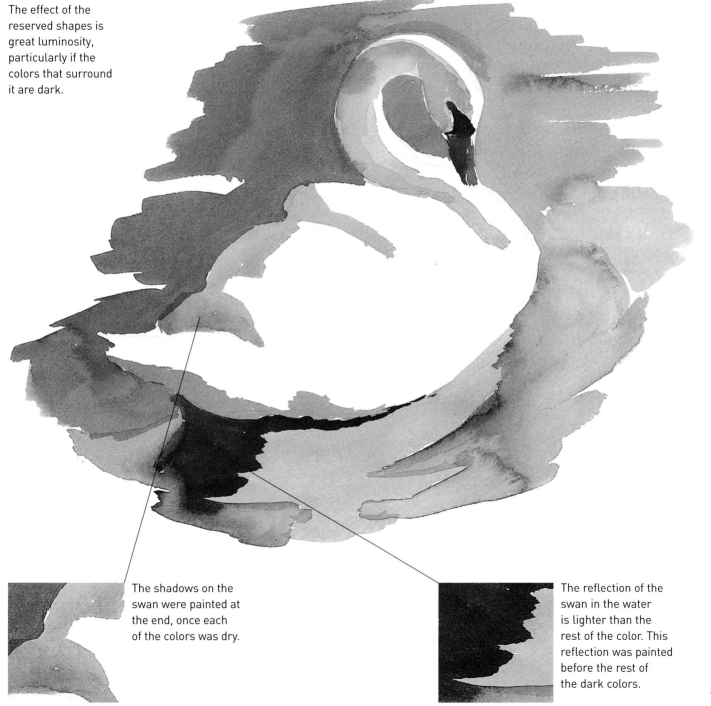

The shadows on the swan were painted at the end, once each of the colors was dry.

The reflection of the swan in the water is lighter than the rest of the color. This reflection was painted before the rest of the dark colors.

Working on wet

When we paint on wet color, the results are unpredictable. The new color expands or mixes randomly on the original application. This effect is unique to watercolor painting and cannot be achieved by any other procedure. The result depends on the pigments that come into contact. In general, the effect is cleaner if dark colors are put on top of light colors. It is not advisable to combine more than two colors because the different applications of water will produce murky or muddy results.

Each patch of color is an experiment. The base paint should be loaded with a lot of water and the color that is put on top somewhat less diluted.

The silhouette of the fish is initially painted in yellow and blue. The red is applied on top of these wet colors.

The red has been applied onto the yellow, loaded with water. It has expanded softly and progressively.

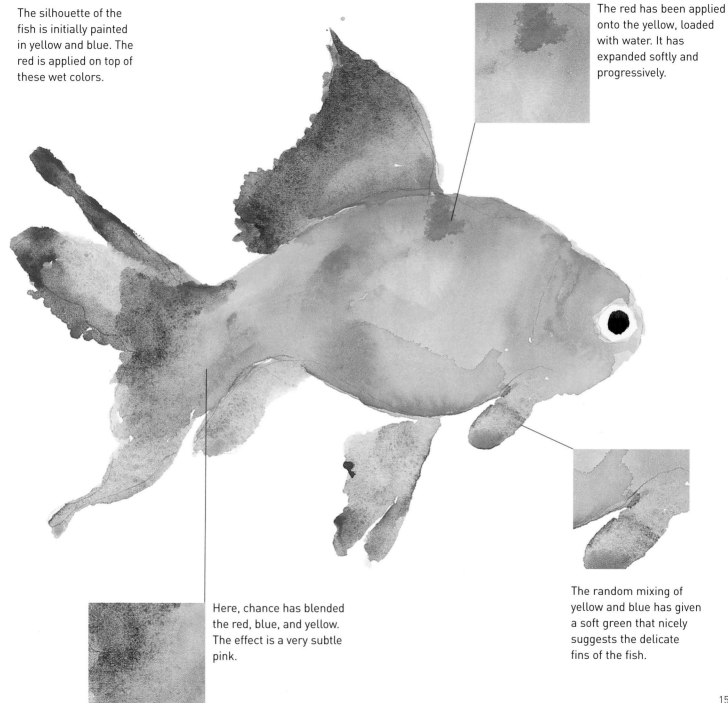

Here, chance has blended the red, blue, and yellow. The effect is a very subtle pink.

The random mixing of yellow and blue has given a soft green that nicely suggests the delicate fins of the fish.

Paper

The paper that we paint onto is almost as important as the colors. It must be able to absorb the right amount of water and hold the pigment on its surface. It has to be thick, such as 140-pound weight (300 grams per square meter). It should be made of cotton fiber. Its surface may be smooth, rough, or very rough. The rougher it is, the larger the amount of water and pigment it will retain, and the colors will be denser and deeper. The smoother the paper, the more precise the outlines of the painted areas and the more luminous the result.

The paper at the top is smooth, the one in the middle has medium roughness, and the one at the bottom is very rough. Each paper offers different advantages. The choice of paper depends on the artist's taste and the effect he or she wishes to obtain.

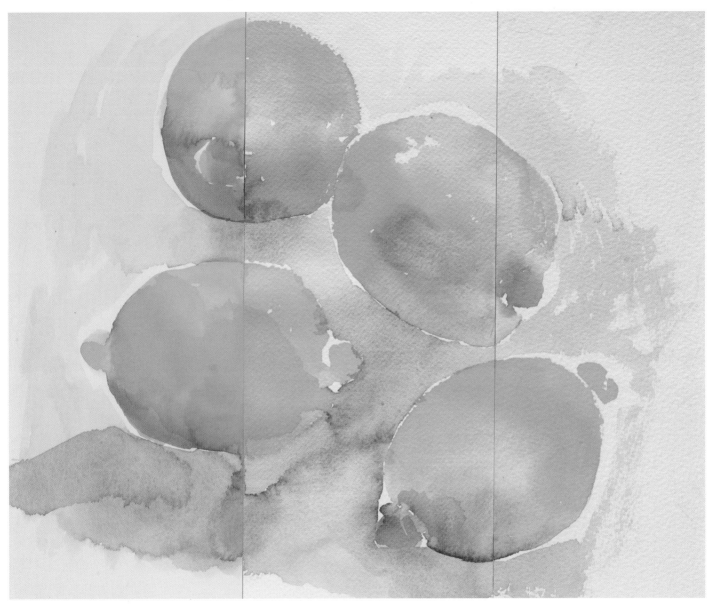

Smooth watercolor paper retains little pigment. The painted areas appear lighter and the outlines cleaner. The rapid absorption of water means that any retouching can clearly be seen.

Rough paper is the most recommended due to its balance in terms of absorption and retention of the color.

Heavy grain paper accepts abundant water and a lot of paint. The effect of the paint is dense and deep on this kind of paper, but it does not enable shapes to be outlined.

Mixing colors

The result of any mix between two or more colors can be predicted, bearing in mind the basic mixes between the three primary colors: blue, red, and yellow. A mix of blue and red gives violet; blue and yellow give green, and yellow and red give orange. These results vary depending on which blue, red, and yellow we use, but these are the general rules. The proportions of each color, as well as the degree of saturation, are also crucial factors. It is advisable that we start by mixing a little color and then gradually adding a little more of one or another until we achieve the required tone.

The three primary colors give rise to the rest of the basic colors on the palette. This does not mean that we have to paint with just three colors, but that it is important to remember the results of the basic mixes so that we can predict the colors we will obtain.

This circle shows the basic range of secondary colors that we get from mixing the three primary colors: blue, red, and yellow.

primary red

secondary violet

primary blue

secondary orange

primary yellow

secondary green

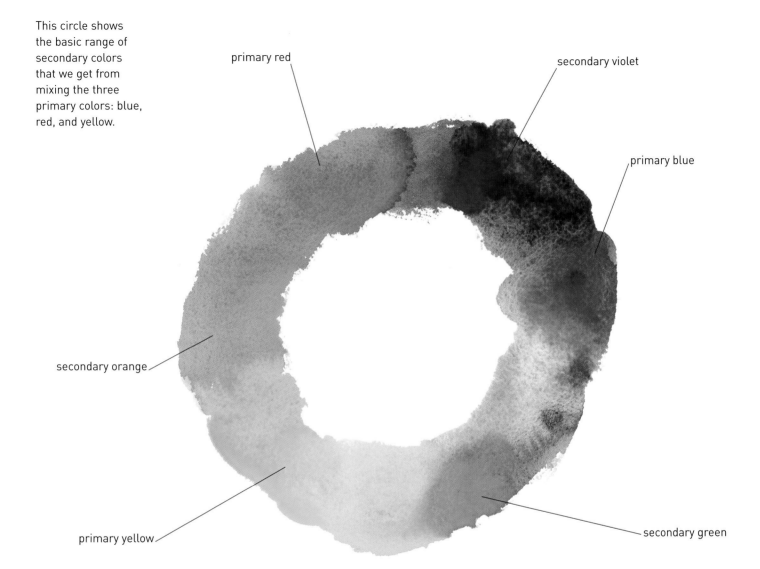

Watercolorists never limit themselves to working with the three primary colors. They need secondary colors (violets, greens, oranges, etc.), of an intensity and purity that it is impossible to achieve by simply mixing the primary colors.

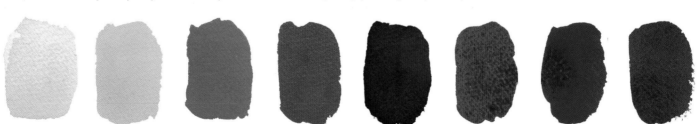

Watercolor processes

A flower
gradations of color

Gradation increases the scope of color. A few colors offer a wide range of shades. All of the petals on this flower can be easily created by saturating or grading just a few colors.

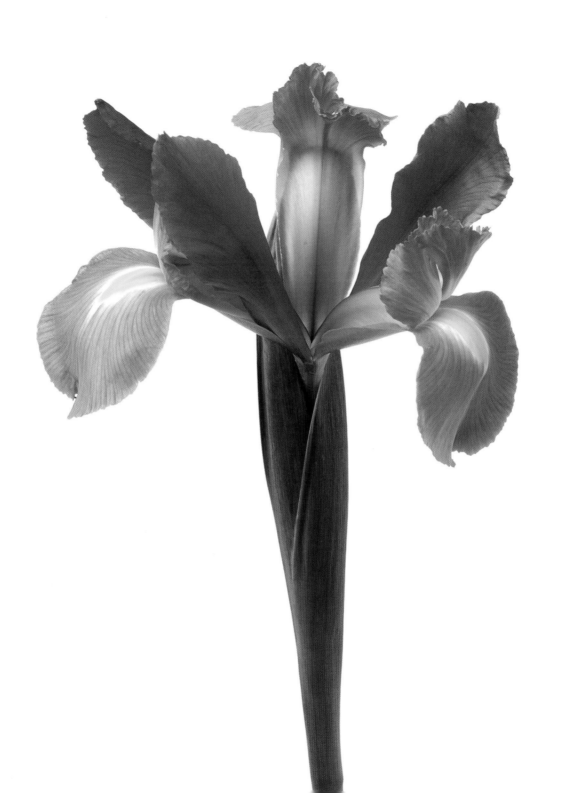

The colors we need

Strictly speaking, we only need blue, violet, and green to portray each of the colors in the flower. However, a second blue will make the task easier.

cobalt violet cerulean blue cobalt blue emerald green

The drawing

Although it looks complicated, drawing the flower is easy to do. The sinuous edges do not have to be faithful to reality: the most important thing is that the petals are in proportion to the whole drawing. The lines should be fine and faint.

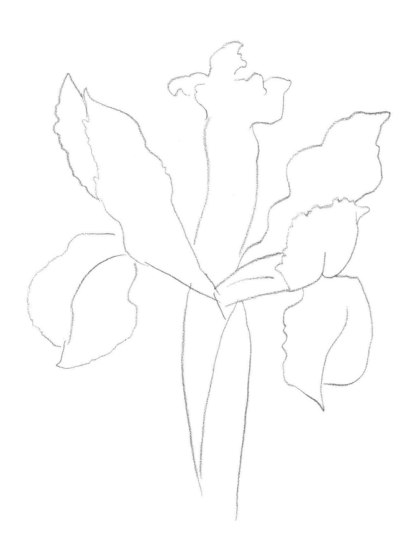

Violet brushstrokes

It is possible to paint the petals using just a few brushstrokes. To do this, it is essential that we load the brush with plenty of water and a lot of paint.

1 | The process for painting the petals is always the same. First, a brushstroke loaded with color gives the shape of the petal according to the lines of the drawing.

2 | The first brushstroke should be saturated with color. Without letting the color dry on the paper, we should clean the brush before spreading out the color we have placed on the sheet.

3 | We spread out and gradate the color accumulated during the first brushstroke with a clean brush that has been slightly dampened in clean water.

What distinguishes each petal is its shape, and this should be created using very few brushstrokes. The brush should touch the sheet of paper as few times as possible.

1

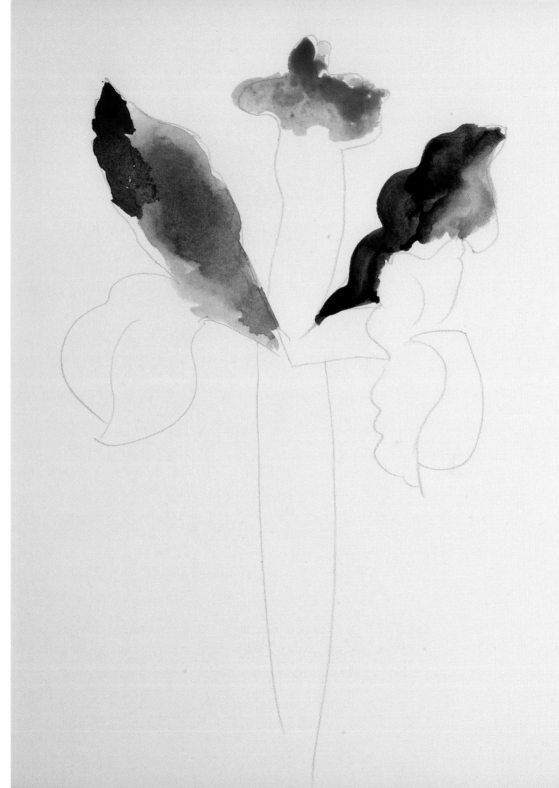

The relief of blue petals

In watercolor painting, light is equivalent to a greater amount of water, and shadow to a greater amount of color. In this way, we create the subtle lights and shadows of these petals.

1 | We apply brushstrokes that are quite saturated with color. Each one gives shape to a relief of the petal.

2 | We define the reliefs using brushstrokes in the shape of a comma applied with the tip of the brush.

3 | With a clean brush dampened in clean water, we lightly spread out the color until we get a very soft film that combines previous brushstrokes.

The blues are
more transparent
the more they
are diluted. Each
petal should
contrast with
its neighboring
petal in shape
and color intensity.

2

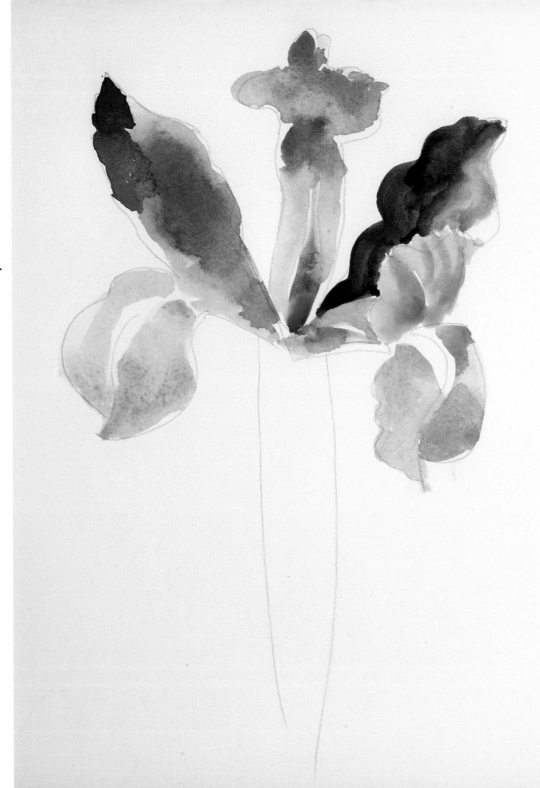

Finally, the stem

Once all the petals are created, the stem is next. This is a straight line that we paint using a simple gradation.

2 | The other half of the stem is darker. We create this by using another vertical brushstroke that gradually decreases in thickness.

1 | A vertical brushstroke defines the shape of the stem. We do not have to wait for it to dry to continue.

3 | The central crease is formed by the line between the two green brushstrokes that define the stem.

We should be able to achieve the desired result with just the right number of brushstrokes. In this example, and in flower paintings in general, each brushstroke counts and has a specific role.

3

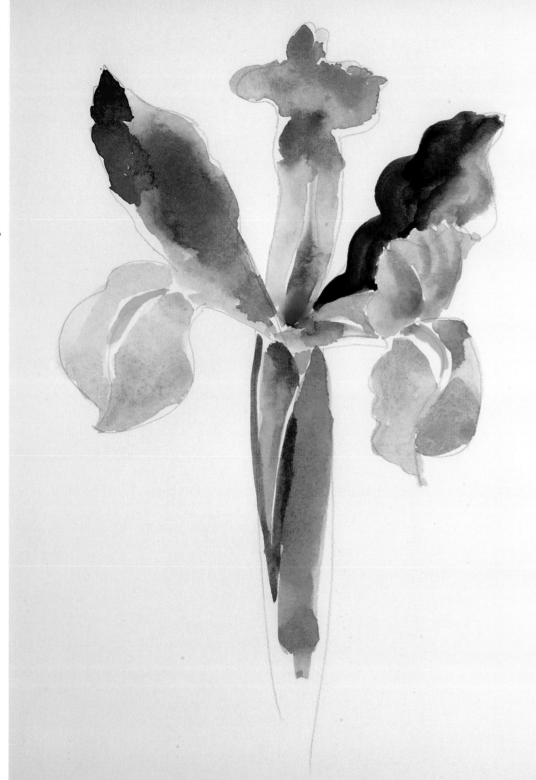

Two fruits color transparencies

The skin of these nectarines suggests a yellow base and a fairly intense red mantle that makes the yellow transparent in different areas. We will now work with color transparencies and gradations.

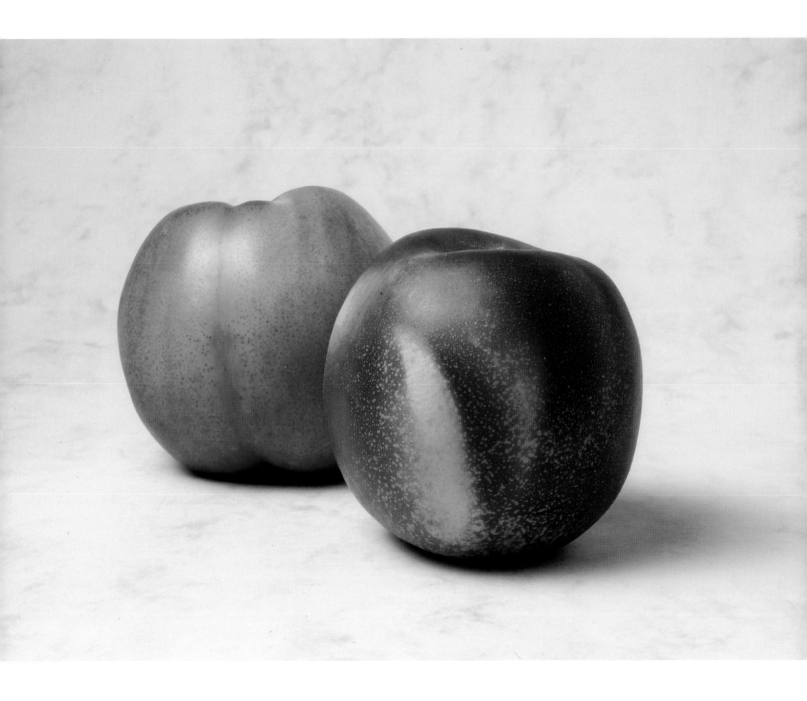

The colors we need

We will use cadmium yellow for the base color of the fruits. We cover the skin of the nectarines with two reds (permanent and carmine). Cobalt blue helps us make up the color of the background.

cadmium yellow permanent red carmine madder cobalt blue

The drawing

Two circles are sufficient to draw these fruits. They are fairly equal and will have to be retouched gradually so that their outline is as similar as possible to that of the nectarines. It is important to draw without pressing the pencil too hard on the paper.

The yellow base

The base color is yellow. We will simply paint it by covering the shape of the fruit with this color. We leave a small white "shine" in the most illuminated area only.

2 | The color reaches the drawn outlines, leaving a small unpainted area where the light makes the smooth and lustrous surface of the nectarine shine.

1 | The color has a medium level of saturation (it is neither very diluted in water nor very loaded with paint) and is applied to the inside of the fruit, spreading it out evenly with the brush.

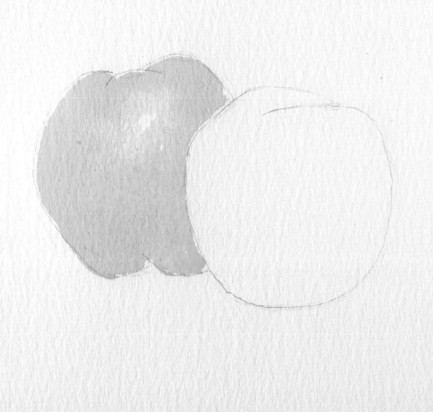

1 The yellow base completely covers the inside of the fruit, precisely outlined by its drawing. Follow the same process with the second fruit.

A transparent red

Before continuing to paint, we have to ensure that the yellow is totally dry, not just the surface of the color but also the paper. If necessary, we can speed up the drying process by using the cold setting of a hairdryer.

1 | The red should be quite diluted so that it is truly transparent and allows the yellow base to show through. We apply the brushstrokes in semicircles, following the shape of the fruit.

2 | Before the red glaze dries, we go over it again around the edges with the color somewhat more saturated, letting the paint spread out freely on the wet paint.

3 | With the glaze still wet, we apply some traces of diluted red with the tip of the brush inside the fruit. We spread out the color again creating a delicate effect.

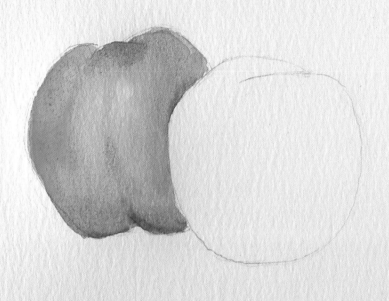

2 Thanks to the transparency of the diluted red blended on wet, the surface of the fruit has the silky and translucent quality that we are looking for.

Opaque areas

The second fruit is much darker. The red should be richer and, in some cases, as opaque as the paint will allow. This means we end up working with very little water.

3 | To blend one brushstroke into another, we wet the tip of the brush and apply it in the area where these two brushstrokes meet.

1 | We first use very diluted paint to create a transparent glaze.

2 | When the glaze has dried, we trace semicircular brushstrokes using very dense color.

4 | We apply darker brushstrokes with the brush loaded with just paint and virtually no water to achieve a practically opaque tone.

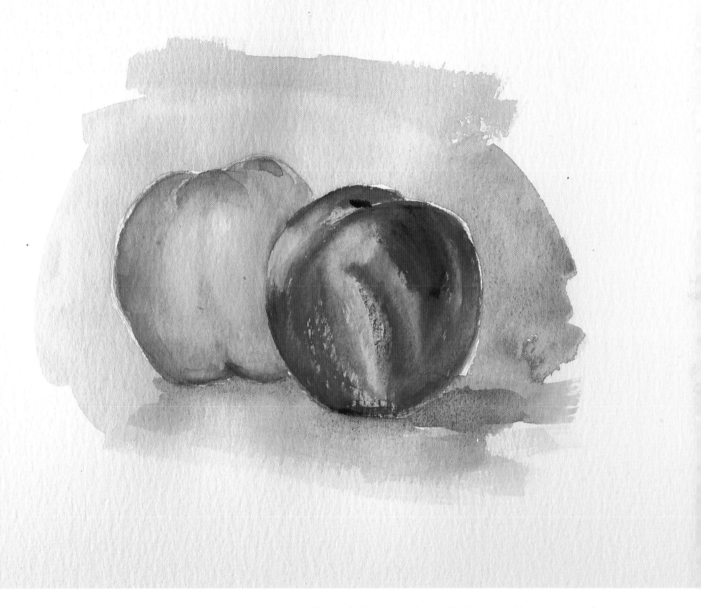

3 The color of the background is a mix of the red and the yellow used in the fruits and a small amount of cobalt blue. We need a very diluted mix for this, using it to surround the shape of the fruits.

Cherries contrasts and gradations

The lustrous red of the cherry contains many different reds that range from pale carmine to deep violet. In this watercolor, we look for these shades and their contrasts to achieve a fresh and luminous effect in a very simple composition.

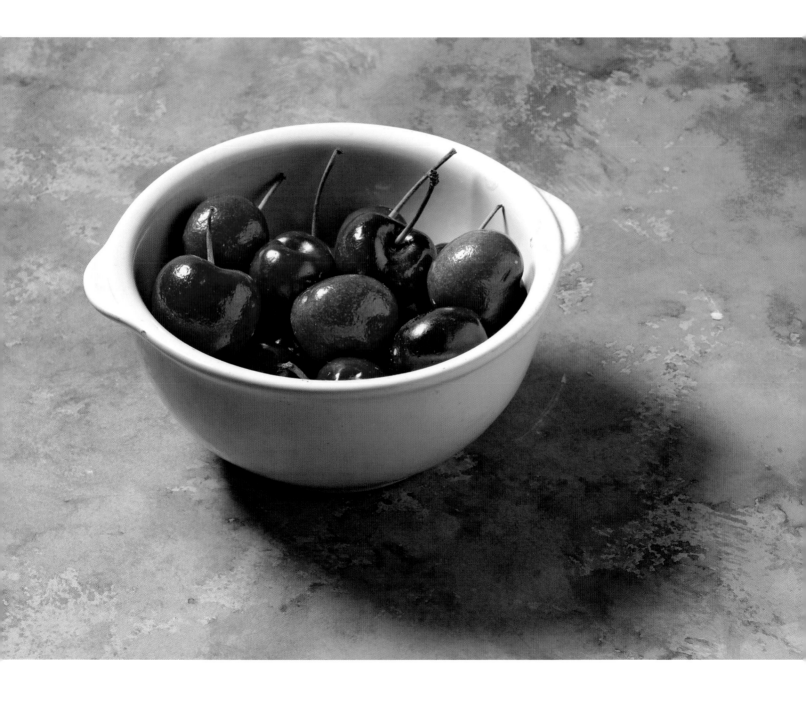

The colors we need

We use three different reds: cadmium red, permanent red, and carmine. The use of blue (permanent blue) helps us obtain violet tones as well as the blue grays of the background and the shadows of the bowl.

cadmium red permanent red carmine madder

permanent blue

The drawing

There are two things to be aware of in this simple drawing:
the size of the cherries is in proportion to the size of the bowl,
and the opening of the bowl is perfectly oval. Other than those,
the drawing should not present difficulties.

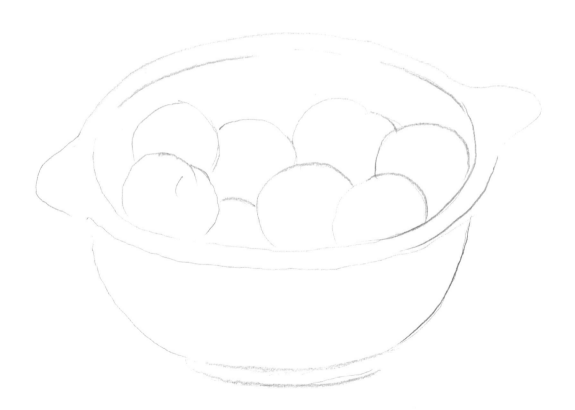

A pale base color

We first paint all the cherries in a very watered-down carmine wash.
We leave small white reserves that will add the shine to the fruits.

1 | We paint each cherry with the carmine wash, surrounding a small white reserve.

2 | The wash should not be totally even; there may be areas darker than others.

3 | We apply more saturated carmine on top of the wash (which is still wet), letting the color expand on the surface of the fruit.

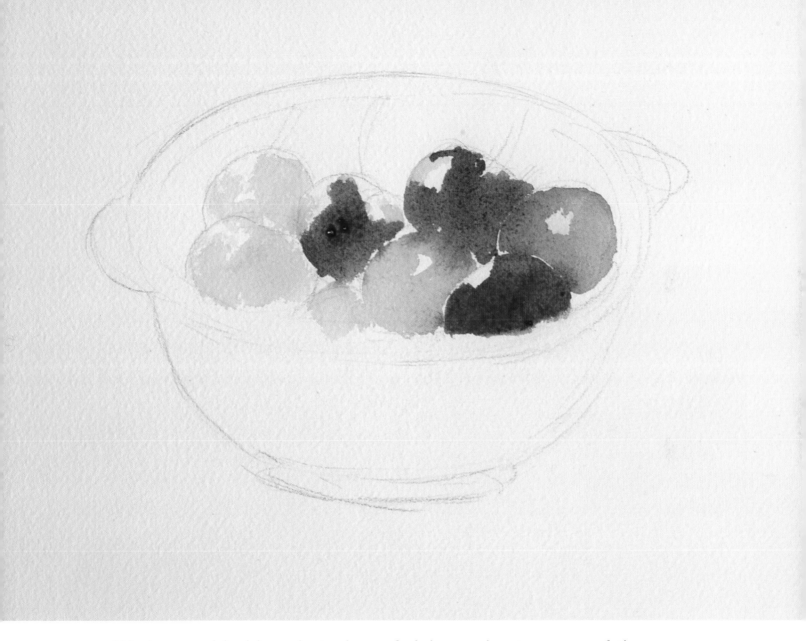

1 We have added brushstrokes of richer color to some of the cherries. The color expands on the wet base and creates very spongy surfaces.

Contrasts between the fruits

It would be a mistake to paint all of the cherries in the same color.
We should contrast reds, carmines, and purples to achieve the relief
of the fruit.

1 | When the painted area
is dry, we use cadmium
red to cover some of the
cherries, always respecting
the small white shine.

2 | Strokes of very saturated
carmine applied with an
almost dry brush create this
partially shadowed cherry.

3 | We add a little blue to
the carmine on the darker
part of the cherry to achieve
a purple shade.

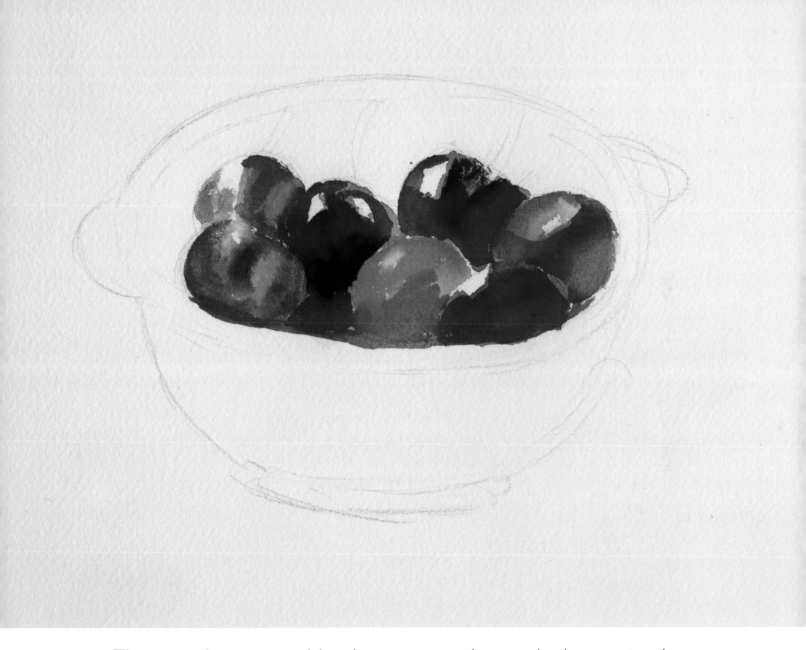

2 The most important thing is to ensure that each cherry stands out from the rest due to its different tones: lighter or darker, redder or more purple.

Grays

Blue grays can be obtained using blue and a little red. We need just blue for the inside of the bowl, blue and red in fairly equal parts for its shadow, and more red than blue for the background.

1 | The body of the bowl is a single area of gray that gives us the whole shape with very few brushstrokes, always respecting the limits of the drawing.

2 | It is very important that we gradate the gray color of the inside of the bowl: darker on the left and getting progressively lighter until it can almost be mistaken for the white of the paper.

3 | We paint the gray of the background with a lot of water and color. The brushstrokes should mark out the edges of the bowl.

4 | While the paint is still wet, we apply a very saturated mix of blue and red to the base of the bowl to create its shadow.

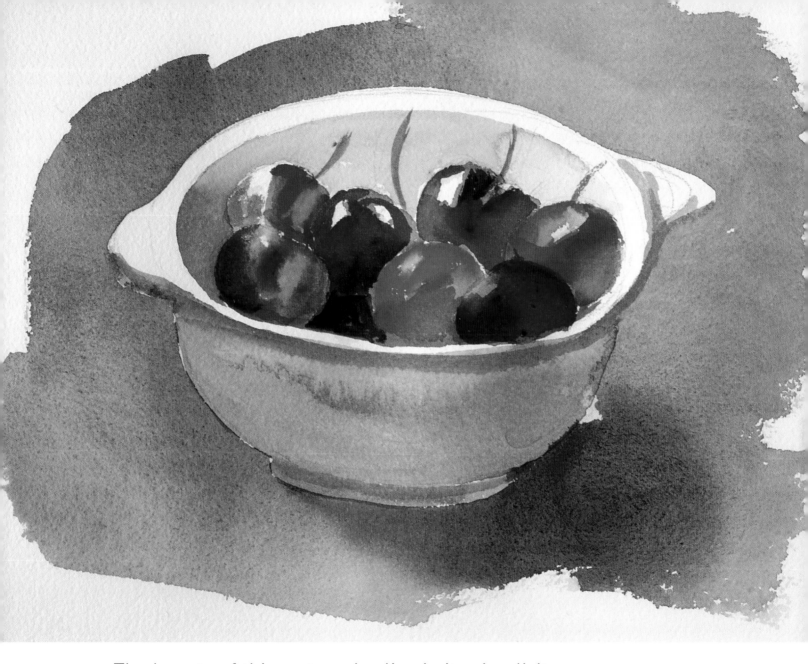

3 The beauty of this watercolor lies in its simplicity.
The painted areas are fresh and are not retouched.
This is a compact and luminous composition.

A swan white reserve

A white shape in a dark environment cannot be painted using watercolor paints: the background is painted, and the shape is left unpainted. The swan that we create in this watercolor is perfectly white and only the shadows of its plumage break up this whiteness.

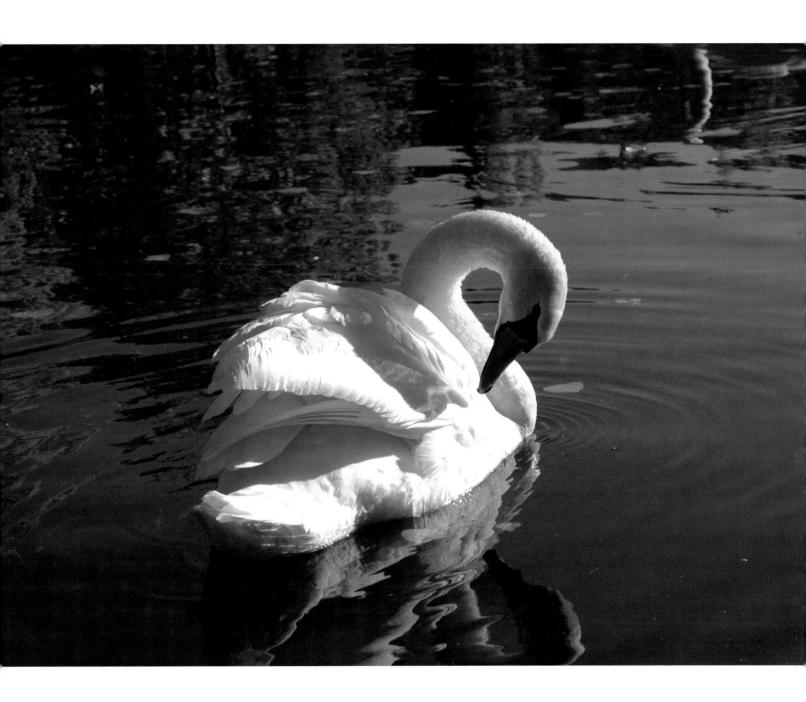

The colors we need

We use just three colors: yellow, red (permanent red), and blue (permanent blue). These are the primary colors; by mixing them we can, in theory, get any other color. This theory is demonstrated in this watercolor.

cadmium yellow permanent red permanent blue

The drawing

We sketch just the swan and its reflection as simply as possible, avoiding any unnecessary detail. It is enough to draw some lines of the outline, aiming to make the curve of the neck as natural as possible.

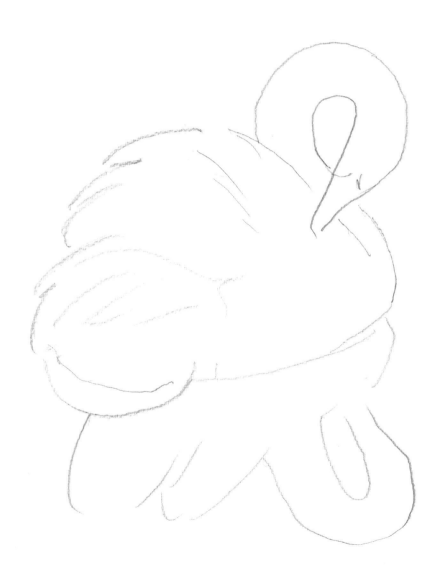

Shadowed feathers

The shadows of the plumage are simply strokes of soft-toned blue.
We paint this plumage with lines or comma-shaped brushstrokes as
if we are suggesting the direction of the feathers.

1 | We paint the
shadows with long and
loose strokes, avoiding
creating blocks of
compact color.

2 | To shadow the
swan's neck, we make
a curved brushstroke
that runs from one
end to the other.

3 | We dilute the previous
brushstroke by passing
over it with a clean,
damp paintbrush.

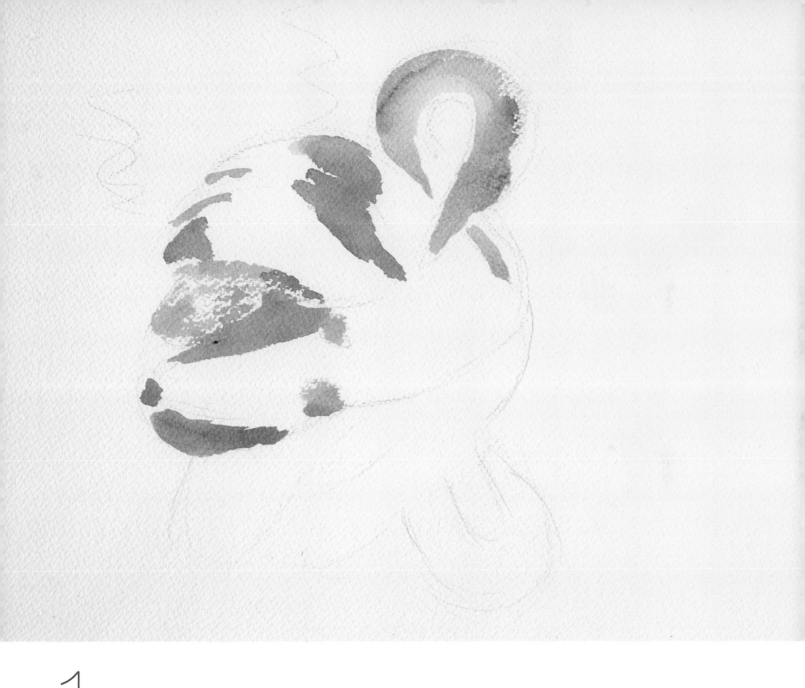

1 This ghostly swan can be recognized by the shadowing of its plumage.

The reflection

The reflection of the swan on the water is much darker. We paint the darkest areas in a greenish gray (blue, yellow, and a little red); the rest of the body will be in the same color that has been watered-down.

1 | The reflection of the tail is the darkest area. The color used here is a greenish grey obtained by mixing the three colors in almost equal parts.

3 | The rest of the reflection is painted in a lighter tone, carefully reserving the white of the animal's body.

2 | We paint the swan's neck as an exact reflection of that of the real swan, but in a darker color, using a long, curving brushstroke.

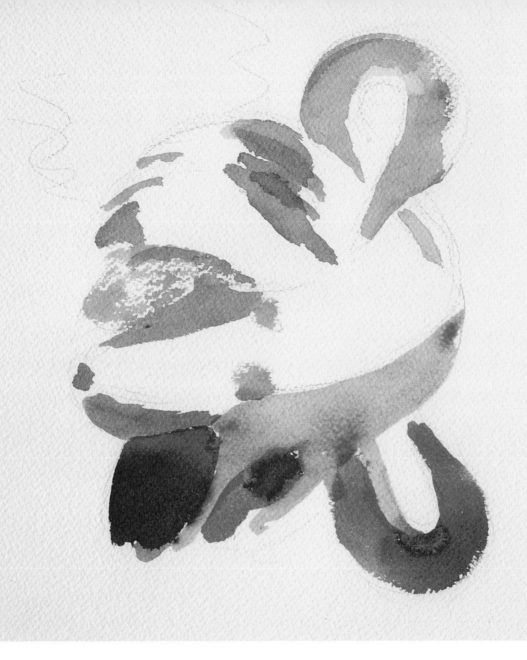

2 The darker tone of these painted areas is characteristic of the reflections on the water; they are always darker than the actual objects.

The silhouette

The water has several tones: greenish in its darkest areas and bluish in the lightest areas. In both cases, we work with mixes of the three colors, where yellow (greenish water) or blue (bluish water) will dominate.

1 | Using the greenish color, we paint around the silhouette of the swan, taking the precaution of reserving the feathers in white. We work with the tip of the brush.

2 | On the other side, the water is more bluish: the blue should dominate when mixing the three colors. As before, we respect the outline of the swan's body.

3 | We represent the waves in the water with darker brushstrokes when the bluish base has dried.

4 | The beak provides the final detail. We carefully apply a small red patch with the tip of the brush.

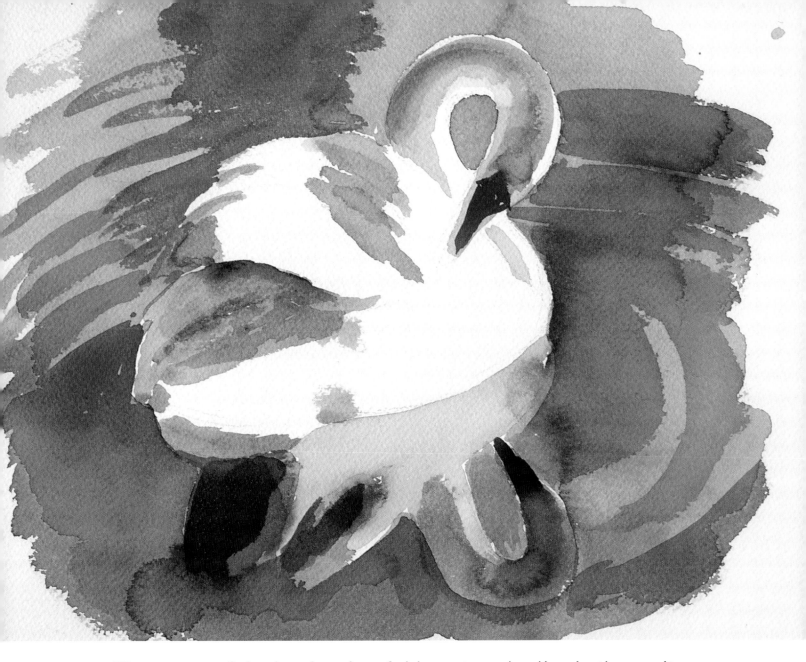

3 The secret of the luminosity of this watercolor lies in the purity of the white of the paper in contrast with the grayish tones of the water.

Tulips
painting
on wet

The colorful flowers are more convincing if we let the colors mix freely with each other. The effect is more spontaneous and natural. The stems and leaves, however, require a little more care.

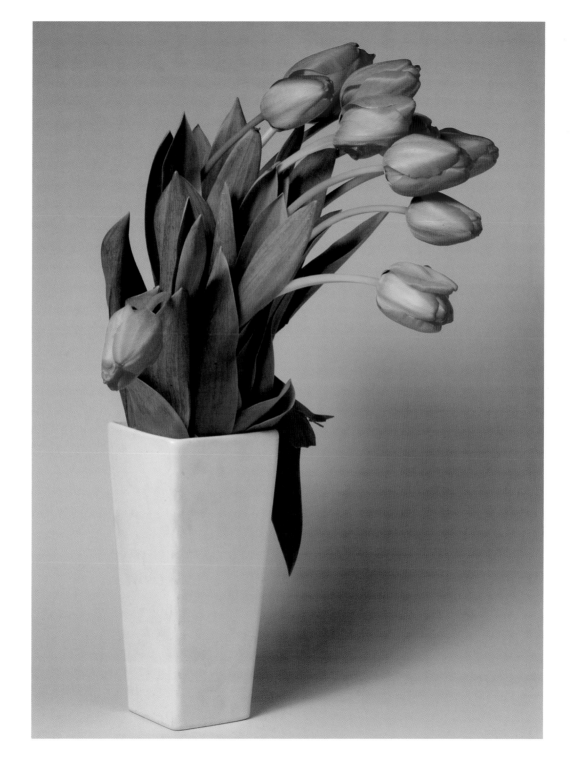

The colors we need

The pink in this range is watered-down magenta; some manufacturers label it permanent pink. Apart from this color, we use cadmium yellow, permanent red, carmine, green, and cobalt blue.

cadmium yellow

permanent pink

permanent red

carmine madder

permanent green

cobalt blue

The drawing

The tulips have an irregular elliptical shape. The stems and leaves can be created using simple lines, paying attention to their positioning within the arrangement. It is recommended that we do not connect all the lines, as this would create a harsh result.

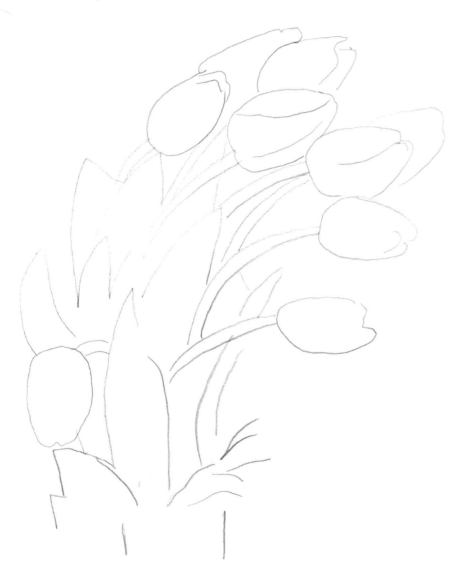

Wet on wet

We first paint the flowers with pink diluted in abundant water.
Immediately after, we retouch the flowers with saturated red, leaving
the brushstrokes to freely spread out on the wet base.

1 | The pink patches should be loaded with plenty of water to ensure that they do not dry before applying the new color.

2 | When we apply the red, the paint spreads out, partially covering the pink. We should not overdo this, as it is better to let the color follow its natural movement.

3 | Using a clean brush, we help the red patch follow in the right direction, spreading it out slightly toward the inside of the flower.

Since we do not retouch the flowers, this means that the color mixes and distributes naturally. This way of working gives us a fresh and vibrant result.

1

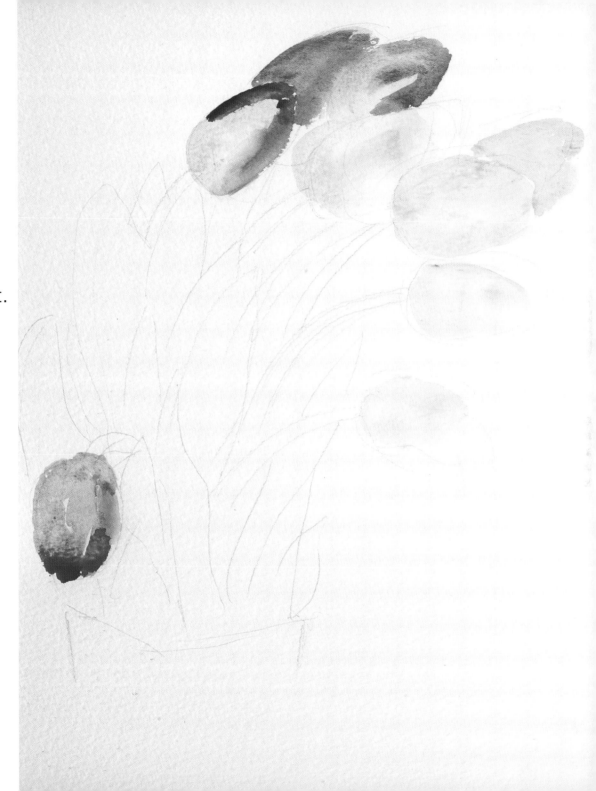

Shades and contrasts

In watercolor painting, light is equivalent to a greater amount of water, and shadow to a greater amount of color. With this in mind, we create the subtle lights and shadows of these petals.

1 | Using a curving brushstroke, we paint around a pink area in the center of the flower; the red expands on the wet base.

2 | The tips of the flowers are usually darker, and this is where we should first paint with the brush loaded with saturated red.

3 | When they are quite dry, we can slightly retouch the flowers with some touches of vibrant red.

The flowers are now finished. We do not need to retouch them any more as we would destroy the delicate effect achieved by working wet on wet.

2

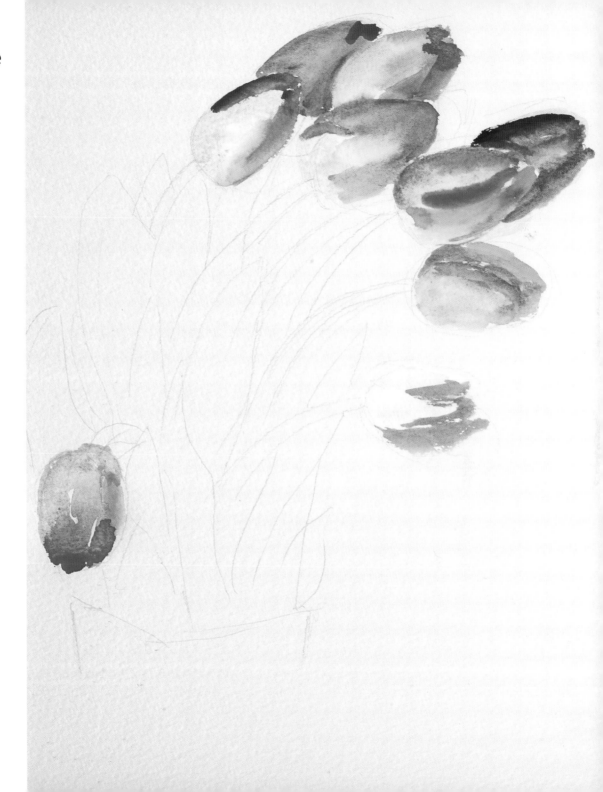

A wide range of greens

It is very easy to create many different greens by mixing the green from our palette with yellow and a little blue. We first paint the stems and leaves with very diluted greens and then add the dark greens to contrast with the initial areas that were painted.

1 | The stems are simple curving brushstrokes in a single color that has been diluted considerably.

2 | We create the leaves with a long, broad expanse of paint, with the brush loaded with a fair amount of color.

3 | We easily create the smallest leaves by "drawing them" with the tip of the brush. We use shades of the same green that we used for the stems.

4 | Once all the leaves are painted, we mix a darker green (using more blue) to provide contrast to their edges. The outlines can therefore be seen more clearly.

The background color is in a blue diluted in plenty of water. This has to be applied carefully, following the outline of each flower and each leaf. This blue will be darker where the tulip flowers are lighter in color.

3

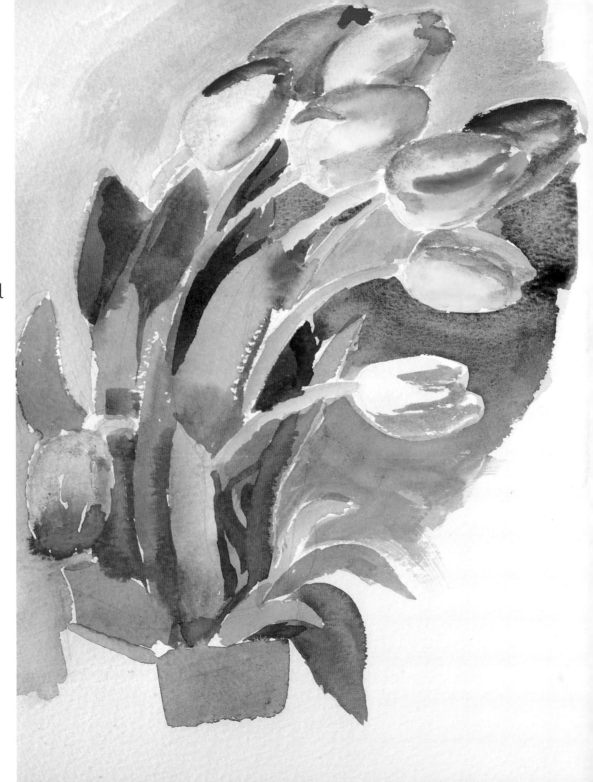

Toys wash and polychrome

A wash involves painting using just one color. Polychrome involves painting using many colors. Both techniques are used in this work. A wash is used to create the figure of the teddy bear using only grays. The rest of the watercolor will be an exercise in vibrant and contrasting colors.

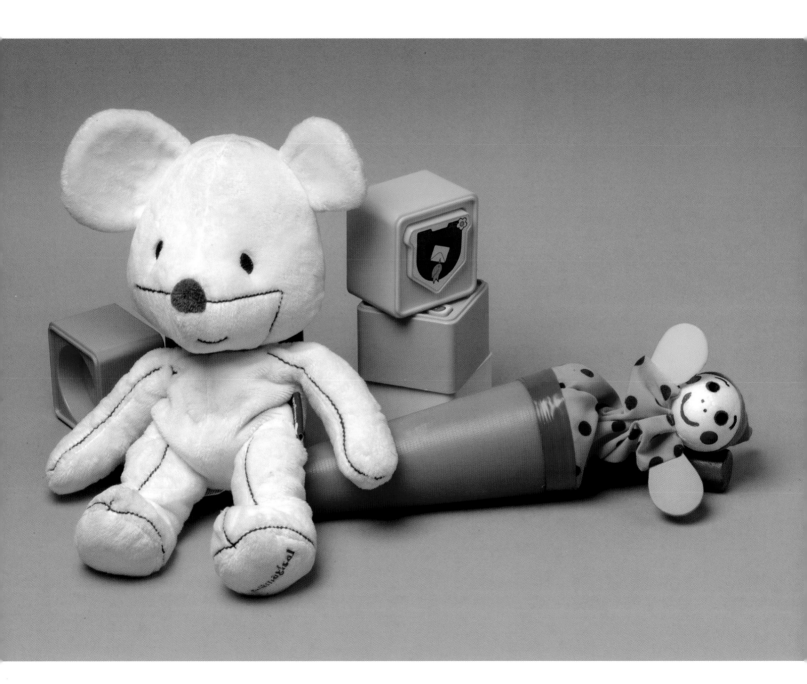

The colors we need

There is a lot of color in the subject, and there are many colors on our palette: lemon yellow, cadmium orange, cobalt violet, cobalt blue, ultramarine blue, and permanent red.

lemon yellow

cobalt violet

ultramarine blue

cadmium orange

permanent red

cobalt blue

The drawing

These toys should be drawn simply, and we do not need to be too precise. These simple shapes have their own charm, and the aim is to bring this charm and simplicity to life.

The wash

On the teddy bear, we only paint the shadows and nothing more, since the teddy is white in color. These shadows are a very diluted mix of blue with a tiny amount of red.

2 | We position the brushstrokes in such a way that, by contrasting with the white, they suggest the shape and creases of the teddy bear.

1 | We spread out the wash with broad, very transparent brushstrokes. We mark the darkest accents with the tip of the brush.

3 | To make the shadows deeper, we add more intense color to the still-wet patches; in this way, the brushstroke loses its outlines and blends into the previously painted areas.

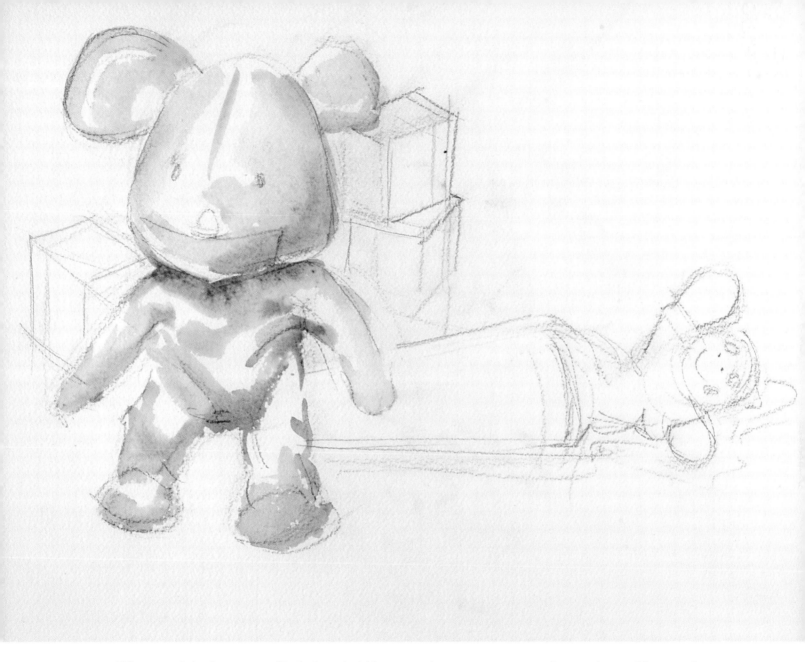

1 The teddy is now finished. We can better appreciate the effect of these strokes at the end of the work when they contrast with the background.

Shades of orange

We paint the orange cylinder, leaving an area clear in the middle so that its shape appears truly curved. This is very easy to achieve.

1 | The orange should be quite dense and saturated so that it covers the white of the paper well, above all in the darkest areas.

3 | We have left an unpainted segment here where the light makes the surface of the cylinder shine.

2 | We cover the shaded area of the cylinder with a richer orange, following the edges of the drawing.

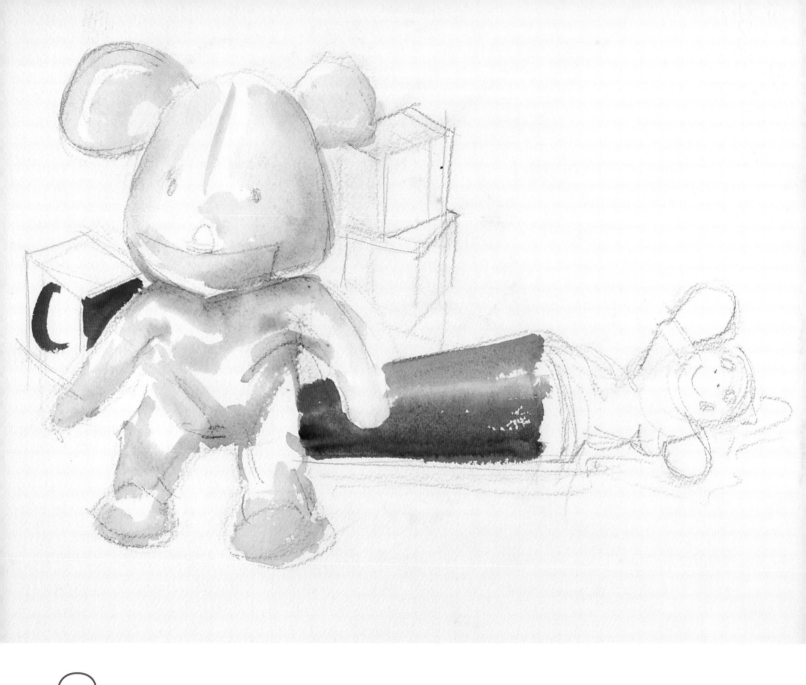

2 The full effect of the cylinder's volume can be appreciated thanks
to the modeling of the color orange from light to dark.

Lights, shadows, and colors

The multicolored blocks that surround the teddy have lighter and darker faces. To create these contrasts, we graduate the dilution of each color: orange, yellow and violet.

1 | Let us look at how we create the violet block: first, we spread out the color (in a fairly diluted tone). This is the color that corresponds to the lit sides.

2 | Using very saturated violet, we mark the edges of the block, drawing them with fine lines with the tip of the brush.

3 | Now we look at the darkest part: we mix the violet with blue, dilute it with a little water, and paint the darkest block.

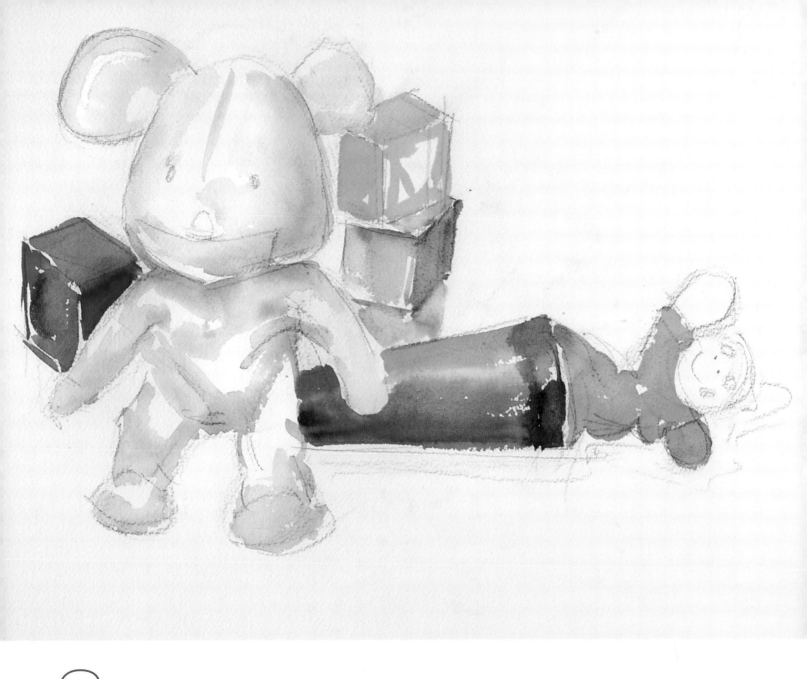

3 The different white hues of the teddy bear become more clearly
defined as we add shapes and colors around it.

The background and final details

As is always the case with subjects that include very light shapes, the real effect is only appreciated when the background is painted. Having seen this effect, all that is left to do is paint in some simple details.

2 | We paint the teddy's seams in blue mixed with very saturated red, drawing in the lines with the tip of the brush.

1 | We have mixed the blue with a tiny amount of green to give it greater luminosity. We cover the background, working with a lot of color, and following the outline of the objects.

3 | The details on the puppet consist of small dots and strokes of pure color that we paint when the watercolor is already dry. This helps them stand out clearly.

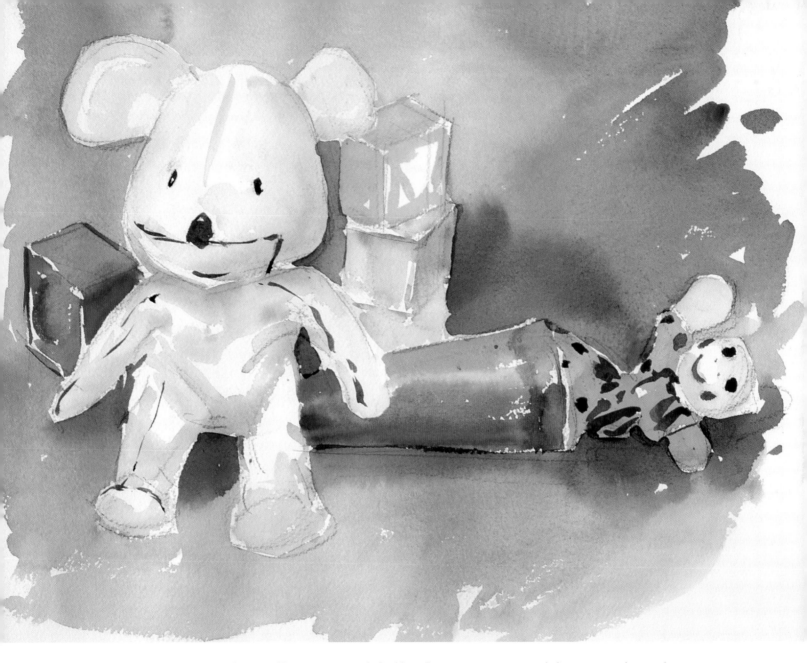

4 Luminous color, vibrant and full of contrasts—this was the aim.
We have achieved this by working lightly and using clean colors,
without overloading the paints.

Washes, transparencies, and working on wet

In this watercolor we are going to apply each of the techniques that we have practiced during the previous exercises: washes, gradations, transparencies, reserves, and wet color on wet paint. This painting is a little more laborious, but if we break it down into several parts, it is simple to do.

The colors we need

We will work with a palette made up of cadmium yellow, cadmium orange, permanent red, cobalt violet, and ultramarine blue. These colors are more than sufficient to achieve a wealth of shades.

cadmium yellow

cobalt violet

cadmium orange

permanent red

ultramarine blue

The drawing

The important thing to bear in mind here is that the size of each object is correct and that they fill the paper comfortably. It is preferable to draw them too large than too small. It is not wise to completely finish the drawing; we should leave some alternative outlines for when we spread out the color.

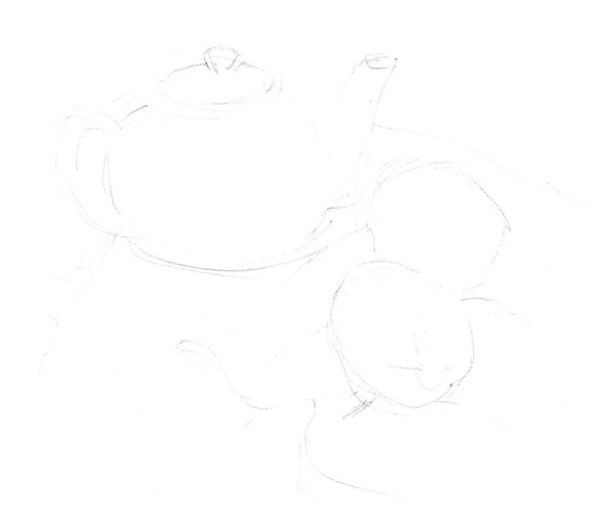

A very pale wash

As is almost always the case when we paint large white objects, we first have to shade this white with a wash to give it volume. For this, we use a blue to which we add a small hint of yellow during painting.

2 | We load the brush with water again, take a very small amount of yellow, and apply it immediately to the wet paint.

1 | This is a very diluted wash: it contains a lot more water than color. We spread it out generously on the round belly of the teapot.

4 | Immediately after tracing the shadow, we go over it again with the brush loaded with just water so that it spreads out and blends in with the rest of the wash.

3 | We create the shadow of the lid with a single stroke of slightly darker blue, retracing the line of the drawing.

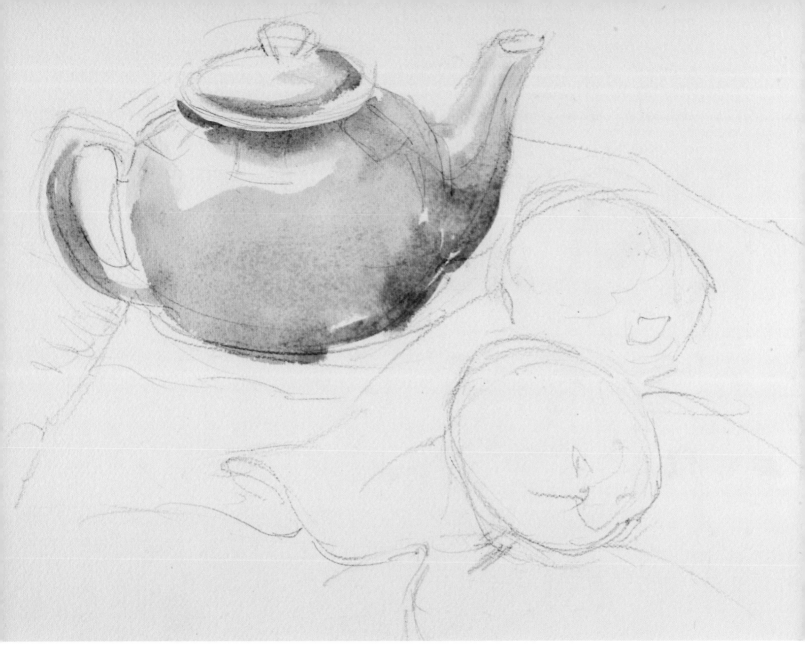

1 Using the wash, we have given volume to the teapot. The darkest parts shade into the lightest areas, and these become almost as pale as the white of the paper.

The yellows of the lemon

A new wash, yellow this time, is used to create the lemons. We use a pure yellow and a "dirty" yellow, one mixed with red and a small amount of blue.

1 | We use a lot of color and enough water to cover the surface of the lemon with a single application of the brush.

2 | We paint the shadow of the lemon with the same yellow mixed with some red and a little blue. We apply this onto the previous color, which is still wet.

3 | The shadows of the lemon follow the yellow of the prominent part of the fruit. This is a simple way for us to create its shape.

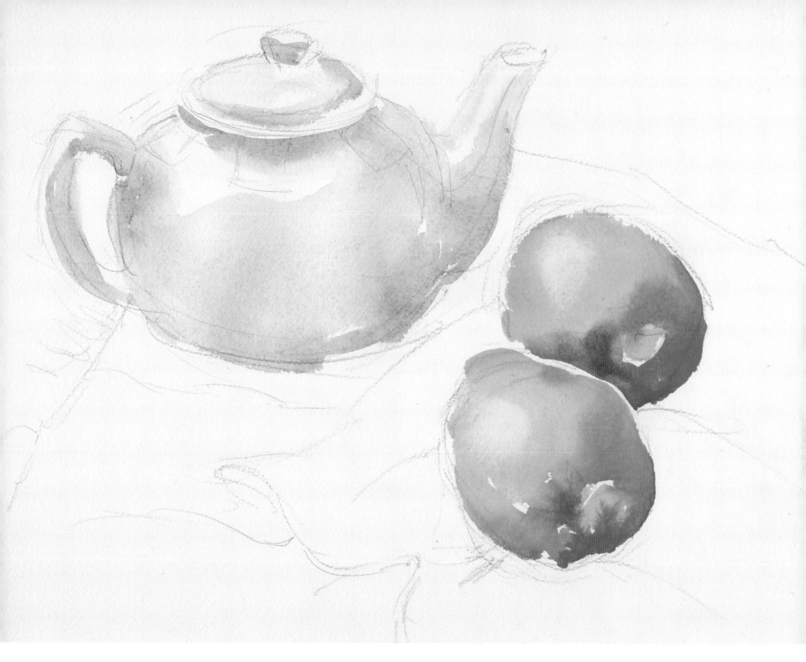

2 Using just a few strokes, we have finished painting the lemons.
By spreading out the color of the shadows with the wet yellow,
the colors have blended by themselves.

Transparent colors

The easiest and most efficient way of creating the colors of the cloth is by using transparencies with an ocher base and some bluish glazes. The lights and shadows of the folds can be simplified.

1 | This ocher is a yellow painted with red and some blue. We need to spread it out with a lot of water, adding more color in the shaded parts.

2 | We outline the underneath of the teapot, applying the same color with more blue. We also let this spread out on the wash of the cloth.

3 | When all of the wash of the cloth is totally dry, we use very light blue to paint the cloth, following the pattern.

4 | We paint the blue patterns following their approximate shape: the distorted effect of the blue squares portrays the folds of the cloth very well.

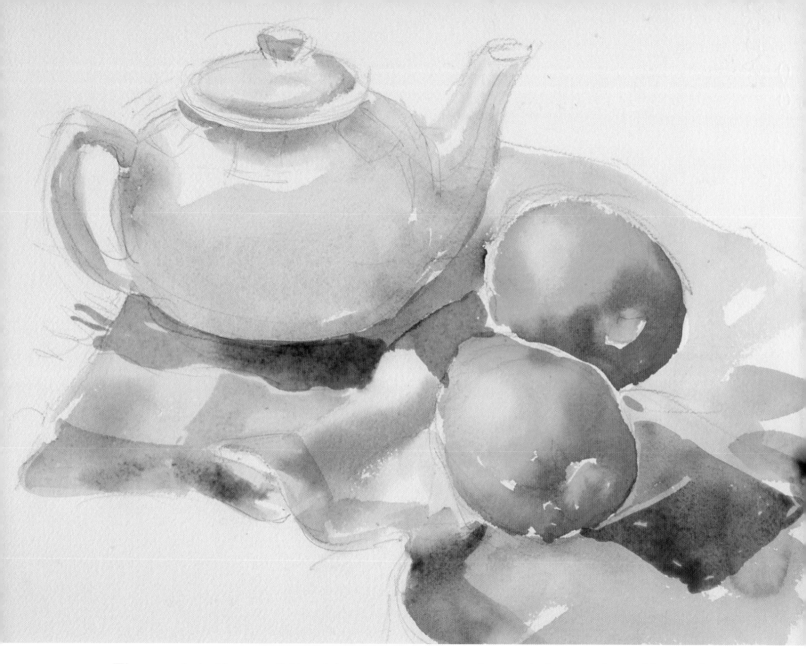

3 The undulations of the blue transparencies reinforce the effect of the folds and add character and a sense of shadow to the darkest areas of the wash.

An expanse of purple

To prevent the harshness of saturated red, we paint the background with carmine darkened with blue. We paint it when all the paint already on the paper is totally dry, surrounding and reserving the painted shapes. The intense color of the background makes these shapes stand out.

1 | We blend generous amounts of carmine and blue with plenty of water and spread out the color on the paper with the brush totally drenched.

2 | As we paint, we profile the outlines of each object.

3 | We leave the flecks in reserve, in white, painting between them with the tip of the brush.

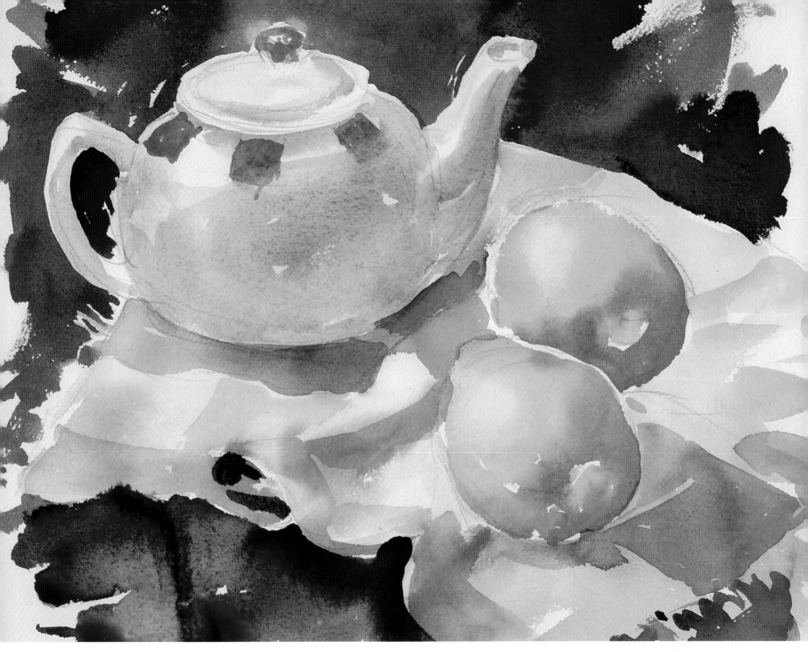

4 The background gives strength and luminosity to this watercolor. The delicate washes and transparencies stand out much more. It even looks like it has been a difficult watercolor to paint, but it is quite the opposite.

Author:
Parramón's Editorial Team

Project Manager:
Maria Fernanda Canal

Editor:
Cristina Viella

Editorial Assistant and Picture Archive:
Mª Carmen Ramos

Text and Coordination:
David Sanmiguel

Exercises:
David Sanmiguel, Óscar Sanchís

Graphic Design:
Soti Mas-Bagà, Pilar Cano

Three Dimensional Design:
Pere Duran

Layout:
Pilar Cano

Photography:
Parramón Archives, Nos & Soto

Production Manager:
Rafael Marfil

Production:
Manel Sánchez

All inquiries should be addressed to:
Barron's Educational Series, Inc.
250 Wireless Boulevard
Hauppauge, New York 11788
www.barronseduc.com

ISBN-13: 978-0-7641-4437-0
ISBN-10: 0-7641-4437-5

Library of Congress Control No. 2009931274

Printed in China
9 8 7 6 5 4 3 2 1